acrylics

Author: Parramón's Editorial Team
Illustrator: Parramón's Editorial Team

Library of Congress Catalog Card No. 97-42797
International Standard Book No. 0-7641-0549-3

Library of Congress Cataloging-in-Publication Data
Para empezar a pintar acrílico. English.
 Learning to paint, acrylics / [author, Parramón's
Editorial Team ; illustrator, Parramón's Editorial Team].
 p. cm.—(Barron's art guides)
 ISBN 0-7641-0549-3
 1. Acrylic painting—Technique. I. Parramón Ediciones.
Editorial Team. II. Title. III. Series.
ND1535.P3613 1998
751.4'26—dc21 97-42797
 CIP

Printed in Spain
9 8 7 6 5 4 3 2 1

BARRON'S ART GUIDES

LEARNING TO
PAINT
acrylics

BARRON'S

Contents

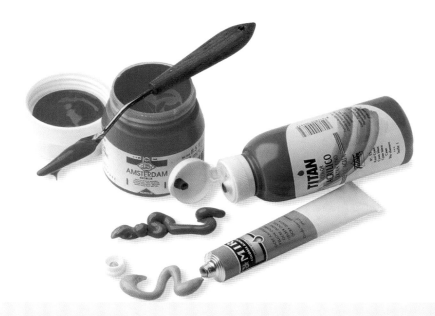

Although acrylic paint is a relatively new invention in the history of art, it has quickly established itself as a popular medium for artistic expression. The secret of its success lies in the versatility of the paint, its fast-drying capacity, and the ease with which it can be diluted with water.

Such characteristics permit the painter to correct errors easily, and apply the paint in either thick or thin layers similar to watercolor. But despite its relatively easy handling, there are certain difficulties in painting with acrylics. This volume has been designed as a step-by-step introduction to the acrylic medium, so that the novice can discover not only the materials, but tricks of the trade, and techniques for producing special effects.

If you are tempted to try your hand at acrylics, you will quickly discover how easy it is to paint with them. You should keep in mind, however, that it takes perseverance and practice to get the results you really want. But don't worry—if you learn each step properly, you will reach your goal.

Acrylics **Introduction**

5

Acrylic Paint

Since acrylic paint has much the same consistency as oil, it is sold in the same types of packaging; acrylics, however, are different from oils in two ways: They can be thinned with water before application, and they dry very quickly.

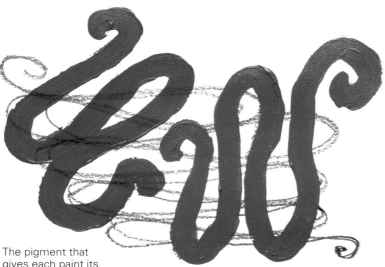

The pigment that gives each paint its color also determines its degree of opacity and transparency. Magenta is a transparent color that allows the pencil lines of a drawing to remain visible through the paint; this green is opaque and covers graphite lines.

Acrylic paint can be purchased in a wide variety of containers.

Composition of Acrylic Paint

Acrylic paint is made up of colored pigments and an acrylic resin emulsion that binds everything together. This substance gives acrylics the consistency of paint, allows them to dry quickly, and be thinned with water. In fact, the acrylic paint you buy has the same characteristics as acrylic resin.

Characteristics

The main characteristics of acrylic paint are its rapid drying time, since it dries by evaporation, and its solubility in water, which means it does not have the disagree-

The tube, the lightest and most easy to transport container, comes in various sizes.

Bottles are handy for the artist who requires large quantities of a color and mixes on the palette, since the cap has a tip incorporated into it to control the flow of paint.

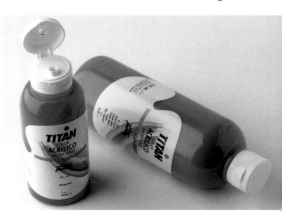

able smells of turpentine and other solvents; its stability, which keeps the colors intact after drying and is highly resistant to light; its versatility, because it can be applied in dense or thin watered-down layers and used as in watercolor paint.

Qualities and Recommendations

Beginners don't need to work with high-quality paints. The most important thing is to learn the techniques and understand how acrylic behaves. On the other hand, you should not use low-quality materials either. Medium-quality paints are best, since they are not expensive, and allow beginners to work with a wide range of colors.

What You Can Buy

Acrylic paint can be bought in tubes, jars, or plastic bottles.

Tubes. The sizes of tubes range from between 35 ml and 60 ml, although white is also sold in tubes of 200 ml because it is the most frequently used color.

Jars. Jars of acrylic paint are sold for painters who use large quantities of color. The most common types come with a screw cap, so the paint must be removed with the

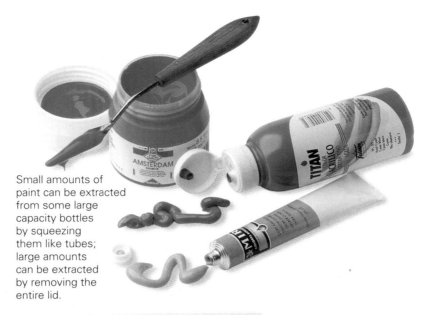

Small amounts of paint can be extracted from some large capacity bottles by squeezing them like tubes; large amounts can be extracted by removing the entire lid.

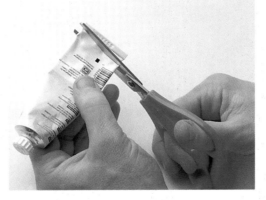

When the top is completely blocked or the paint has dried up because the cap was left off, the remaining paint can be extracted by cutting the bottom of the tube away.

aid of a palette knife; some brands also include a small tip within the cap itself.

Bottles. These are handy for artists who paint on large canvases but still like to use a palette, since the special cap allows small and large amounts to be extracted.

The capacity of jars is similar to that of bottles, and, while some brands include a small tip, the real advantage of using them is their wide neck, which allows artists to extract a large amount of paint at one time.

Although tubes preserve paint best of all, it is important to replace their caps once you have finished using them, as acrylic dries fast and may become unusable.

Hair or Bristle

Ferrule

Handle

Brushes

A brush is the implement used to spread paint over the canvas; the shape and type of hair are two factors that determine the use of a brush.

Composition of the Brush

A brush is made up of three parts: the handle, the ferrule, and the hair.

The handle is the part used to hold the brush when painting.

The ferrule is a thick metal band that keeps the hairs attached to the handle. Its thickness depends on the number of the brush—the bigger the ferrule, the longer the hair.

The hair is the part used to apply the paint to the canvas. This is the most important part of the brush, since it determines its quality and function.

Types of Hair

Brushes for acrylics can contain different types of hair for different purposes.

Professional painters have a variety of brushes made of all kinds of hair so they can have one to suit every need. Despite this, all painters have their preferences and tend to work mainly with a brush made of one type of hair.

Pig's Bristle. This is a natural, very strong hair, stiff enough to use for painting impasto. It is absorbent, and good for loading paint. Bristle is particularly good for making thick brushes, and those used with house paint.

Synthetic Hair. There are various types of synthetic hair; the most suitable for acrylics are those of medium hardness with plenty of flexibility. This type of hair is not as absorbent as bristle but is still good for painting with acrylics. They can be thick or fine, the latter of which is used for painting details.

Others. Ox hair and sable hair are very soft and used for applying very thin, diluted paint or for painting intricate details.

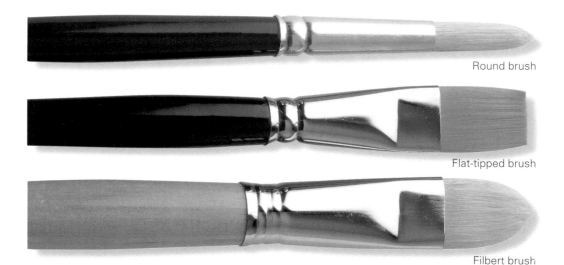

Round brush

Flat-tipped brush

Filbert brush

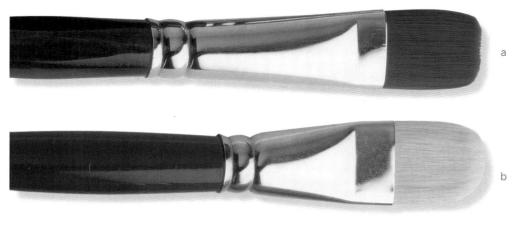

Synthetic hair is soft but strong, and very versatile (a). Pig's bristle (b) is stronger and more absorbent than synthetic hair.

a

b

Types of Brushes

The shape of the hair determines the type of brush; they may be flat-tipped, filbert, or round. Each one has its own particular function, although all three are very versatile and can be used with other media.

Round Brushes. These are the most versatile brushes, since their shape can produce either fine or thick lines.

Flat-Tipped. The hairs of this type of brush are all the same length; it is useful for outlining and painting thick lines.

Filbert Brushes. They combine the characteristics of the round brush—the tip is round—and the flat-tipped brush, since their hair is attached by a flat ferrule, making them versatile and easy to work with.

Rubber-tipped brushes are a relatively new invention. They cannot hold much paint, although they can be used to create interesting effects.

Paintbrushes

These extremely wide and thick brushes—often used to paint houses—are ideal for filling in open spaces, priming canvases, or painting backgrounds.

The familiar brush used for house painting comes in a wide variety of sizes.

Qualities and Recommendations

It is best to start off with medium-quality brushes, those made of a mixture of pig's bristle and synthetic hair. This way, you will discover which type of brush and hair best suits your needs. In the chapter Using a Brush, pages 24–25, you will find a wide range of brushes that you can choose from.

Supports

Both the versatility and adhesiveness of acrylic paint allow it to be applied to a wide variety of supports, from raw canvas to a sheet of wrapping paper.

Acrylic can be applied to primed or unprimed canvas.

Primed canvas is also sold mounted on a wooden stretcher or attached to cardboard or a wooden board.

Canvases

The canvases used for painting in acrylics are the same as those used for oil painting; the only difference is the type of primer used to prepare them.

Acrylics can be applied to either raw or primed canvas. Canvas can be purchased already mounted on a wooden stretcher or in rolls, so painters can mount and prime it to their own liking. Canvas can also be purchased unmounted but ready to paint on.

Canvas can also be bought attached to a cardboard support; the result is light and easier to carry than the type mounted on a stretcher.

The way stretchers are put together is one factor that distinguishes them from each other.

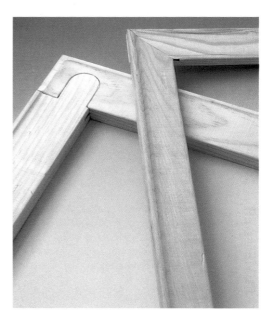

A wide variety of paper and boards is used as supports for painting in acrylic.

Stretchers

The stretcher is the wooden frame that keeps the canvas taut. There is a wide variety of types and sizes to choose from.

You can frame your finished painting. Or you might choose to paint the sides of the canvas that wrap around the stretcher and hang your painting without a frame.

Recommendations

There is not much to say about supports, since the artist can paint on almost anything, even ordinary brown wrapping paper.

It all comes down to experimenting with different supports and working with the one that best suits your needs. It is worth mentioning that the quality of the stretcher is important because it can warp over time and make creases in the canvas.

Other Supports

Paper, cardboard, and wooden board are all commonly used supports in acrylic painting, sometimes for economic reasons, sometimes for the interesting effects that can be produced by their surfaces.

Paper used for watercolor is one of the best kinds to use for acrylics because it is made to deal with water and absorbs paint well. If you are not painting with diluted color, any type of paper that is resistant to brush hairs and dampness can be used.

Primed canvas is the most popular type of support for painting in acrylic. Although the surface is relatively smooth, thin layers of paint bring out the texture and grain of the fabric.

Plywood boards can be used to paint on. Even though acrylic can be applied directly, some artists prefer to prime the boards beforehand. The texture of the wood can be incorporated into the painting.

Watercolor paper is the best kind for acrylics because it can handle water. It also has textured surfaces, like this one, that an artist can work with to add interest to the painting.

REMEMBER . . .

■ Although acrylics can be applied to almost any type of support, it must be able to withstand water and, if it is paper, should be attached to a board prior to use.

Palettes and Jars

In addition to the brush, there are a number of accessories that help the artist apply paint and mix colors.

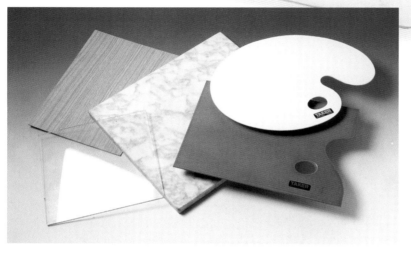

Palettes

The palette is an indispensable tool for holding paint and mixing colors. Any flat surface can serve as a palette, although it is best if it is made of waterproof nonporous material that is perfectly flat so it can be cleaned properly.

Palettes can be made of plastic, wood, and even wastepaper, but most painters prefer to paint with a piece of formica or similar type of laminated, nonporous material.

In addition to the palettes that are sold in art supply stores, acrylic painters make use of any type of flat, polished surface, such as a small door from an old formica cupboard, a slab of marble, or a pane of glass.

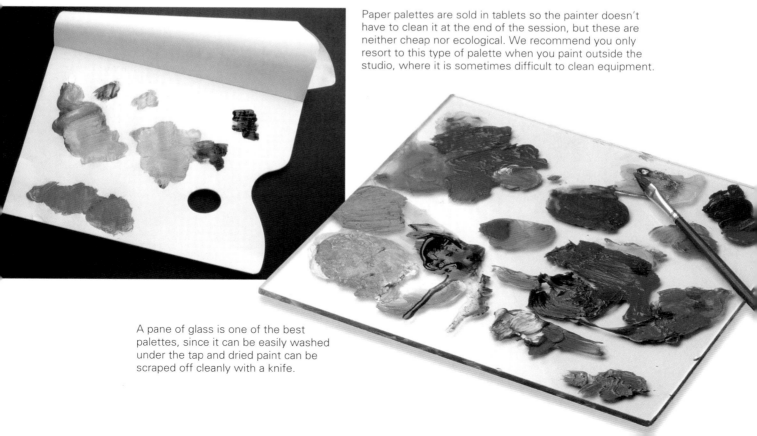

Paper palettes are sold in tablets so the painter doesn't have to clean it at the end of the session, but these are neither cheap nor ecological. We recommend you only resort to this type of palette when you paint outside the studio, where it is sometimes difficult to clean equipment.

A pane of glass is one of the best palettes, since it can be easily washed under the tap and dried paint can be scraped off cleanly with a knife.

Palette Knives

Palette knives are extremely useful tools. They can be used to take paint from a jar and put it on a palette, or they can be used to remove paint leftover from the palette once the picture is completed. They can also be used to paint on the canvas. Use a palette knife instead of a brush to create interesting textures. Each type of palette knife has its own specific use, although they are all versatile and can be used for a variety of tasks. If you do not have a palette knife, you can use an old knife from your kitchen.

Water Jars and Paint Wells

Water jars are essential for painting in acrylics, since they hold the water needed to dilute and dissolve the paint. The artist should actually have at least two handy—one for rinsing the brushes, and one for diluting the paint.

Your jars should be able to hold between a pint and a quart of water so that the water doesn't get dirty too quickly.

Paint wells are small pots or containers that the artist uses to mix large amounts of a color. They come in handy, especially when one needs a large amount of one color to fill in a big area, as a background. You can buy these in art supply stores, or you can use old jam jars or saucers. Practically every container in your refrigerator or kitchen shelves can be recycled as a water jar or paint well.

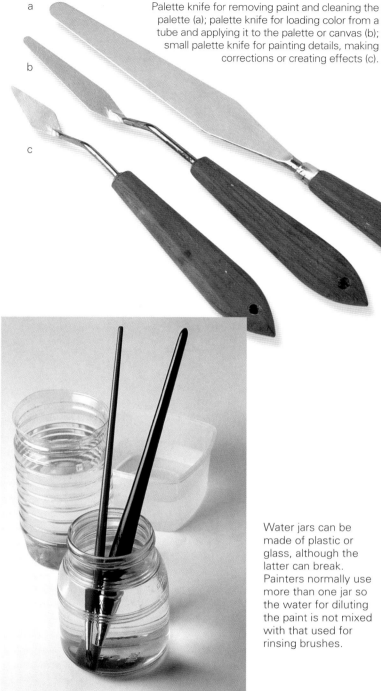

a
b
c

Palette knife for removing paint and cleaning the palette (a); palette knife for loading color from a tube and applying it to the palette or canvas (b); small palette knife for painting details, making corrections or creating effects (c).

Water jars can be made of plastic or glass, although the latter can break. Painters normally use more than one jar so the water for diluting the paint is not mixed with that used for rinsing brushes.

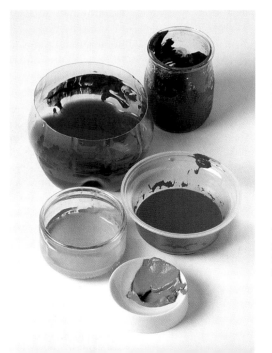

The smaller containers used to mix colors from the palette are called paint wells.

REMEMBER...

■ Any smooth and nonporous surface can be used as a palette.

■ Any small container can be recycled as a paint well.

Easels, Paint Boxes, and Boards

In addition to the obvious materials needed for painting in acrylic, there are several other items that the painter may find useful.

Easels

An easel is a wooden or metal structure designed to support the mounted canvas in a vertical position so that it can be painted on.

An easel is not essential, since a canvas can be placed against a wall or on a table if it is not too big. An easel is more necessary for the artist who paints on a large scale.

If you paint at home and are limited in space, a tabletop easel with a built-in paintbox is the best choice since it serves two purposes.

If you paint in a studio or have a lot of space, you should use a studio easel. These are very sturdy, and allow a board to be firmly attached at either side.

This ingenious box easel allows the lid to double as a palette.

This box palette has a tabletop easel included in the lid that is very handy because it allows an artist to carry his or her paint around easily.

A large, studio-type easel should be sturdy and allow the board or canvas to be attached at either side of the easel to prevent it from moving.

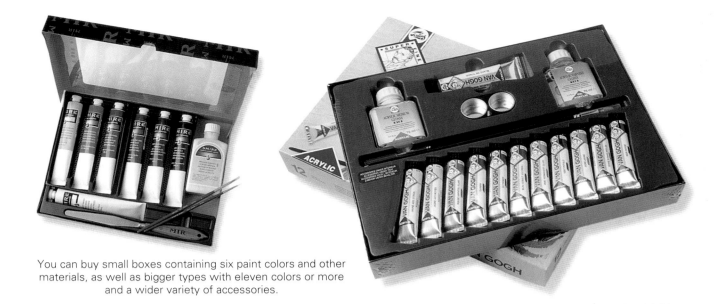

You can buy small boxes containing six paint colors and other materials, as well as bigger types with eleven colors or more and a wider variety of accessories.

Paint Boxes

Boxes in which to keep your painting supplies come in all shapes, sizes, and materials, from fragile cardboard cases to strong wooden ones with carrying handles included. These boxes can be bought already containing supplies or they may be completely empty. The latter type allows artists to fill them with their own range of colors and preferred materials.

Wooden boxes are stronger and more attractive than cardboard ones, and usually include a palette.

REMEMBER . . . ■ You can improvise a paint box using an old briefcase or piece of cardboard, or you can buy an empty paint box in an art supply store and fill it with your own range of colors and supplies.

Boards are used as supports for painting on cardboard or paper so the artist can work on a firm surface attached to the easel.

Boards

Boards are not essential for painting in acrylic, especially if you choose to work on canvas. It is worth having a couple of boards handy in the studio, however, in case you want to paint on paper or cardboard that need to be supported. A board can also be used for drawing, so it will always be useful. When you are painting out of doors, you can balance a board on your knees or against a tree or wall and use it as an easel.

Additional Materials

Art supply stores stock a number of chemical products for use with acrylic paint. These products serve a number of purposes, such as priming the painting surface or altering the consistency of the paint.

Gesso

Gesso

This white paste is used to cover the canvas before paint is applied. It is made up of titanium white pigment and an amount of gypsum plaster or acrylic medium. It is pliant and easy to sand down once dry. Gesso can be mixed with paint to give it color; certain brands sell it in various colors. See Priming the Support, pages 28–29.

Latex

Latex can also be used to seal the canvas before painting or as an adhesive glue for making collages.

Latex

Retarding Medium

This substance increases the humidity of the paint and prolongs drying times, so that artists can treat their acrylics more like oils and can paint at a more relaxed pace and blend colors on the canvas.

Retarding medium

REMEMBER . . .

■ Although using additives with acrylics can expand their versatility and expressive possibilities, it is best for beginners to familiarize themselves with the techniques used to work with acrylics straight from the tube.

Acrylic medium

Acrylic Medium

Acrylic medium is simply the same substance used to bind the pigment of acrylic paint. You can add it to the paint to make it more fluid and transparent if, for instance, you want to paint glazes or apply a transparent priming to the canvas.

Acrylic medium can be bought in gloss or matte form that, when applied to paint, will affect its finish.

Gels and Modeling Paste

Gels and modeling paste

These substances are used to enhance the paint's creaminess, body, and consistency so that the artist can work with textures and relief. These allow the brush or other implements to leave their mark in the paint on the canvas.

Varnishes

Varnish is applied over a dry completed work and is used to give the work a homogenous shiny or matte finish, or for removing the slight stickiness produced by the paint when it is still not completely dry.

Varnishes

Other Accessories

The studio of every acrylic painter should contain a number of additional materials that, while not absolutely indispensable, are very useful to have on hand.

Drawing

To draw the preliminary outline of the picture or sketch the subject on paper, it is essential to have pencils, sticks of graphite, and erasers.

Pencils and lead. These items are used for drawing sketches of the subject before you begin painting it. They are also handy for drawing the preliminary outline of the forms on the canvas.

Charcoal. This is used in the same way as the pencil but is more appropriate for drawing a sketch on the canvas, which will be painted over later.

Ruler and triangles. These are used for drawing angles and straight lines, measuring paper, or for making grids for drawings.

Cutting and Attaching

Whether you are working on canvas or paper, you will eventually have to cut or attach something. There are a number of items you can use for this purpose.

Scissors and utility knife. You should have both of these items handy because, although the knife is versatile and particulary suitable for cutting canvas, scissors will prove more practical on other occasions.

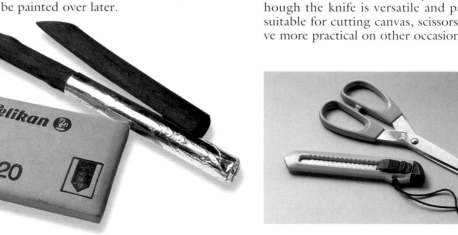

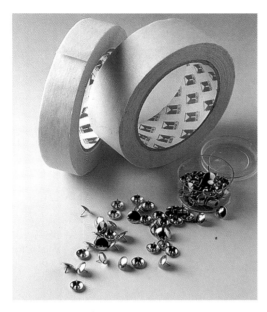

Adhesive tape and tacks. These items are used to attach paper to a board. The tape can also be used to preserve white areas or create effects.

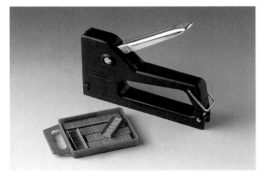

Staple gun. The staple gun is used for attaching canvas to a stretcher. Some artists use it to fasten paper and cardboard to boards. See Mounting Canvas, pages 26–27.

Canvas-separating pins. As their name suggests, these special pins separate one canvas from another when they are stored. This prevents the paintings from coming into direct contact with one another, as well as protecting them from mold due to lack of air circulation.

Cleaning

Both charcoal and acrylic paint stain, so it is essential to have a rag and a bar of soap on hand.

Rags. A rag can be put to use in a variety of ways: erasing charcoal, cleaning your hands, and soaking up excess paint or water from a brush. It can also be used for applying color and creating effects.

Soap. Whether you use a bar of soap or liquid detergent, a cleaning product is necessary for cleaning your hands at the end of a painting session and for cleaning brushes. See Using a Brush, pages 24–25.

Tongs. This instrument is used to tense the canvas before it is attached to the stretcher with staples.

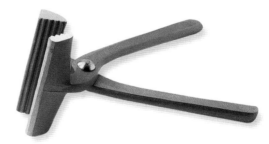

Special Effects

Acrylic paint is extremely versatile and allows the artist to experiment with new methods of applying paint, and to play with textures. Scrubbers and sponges can be used to create unusual marks or textures that enhance colors. See Tricks of the Trade, pages 52–55.

Using the Paint

Acrylic is an extremely versatile type of paint; you can work it like oil or dilute it in water and apply it using watercolor techniques.

Putting Paint on the Palette

Paint from a tube, or a bottle with a tip, can be cleanly placed on the palette, since you can control the amount with relative precision. A jar with a screw cap, on the other hand, is ideal for the time when you need large quantities of a color, but inconvenient when you need just a little, since the paint has to be removed with a palette knife.

A palette knife is needed to transport paint from pots to the palette.

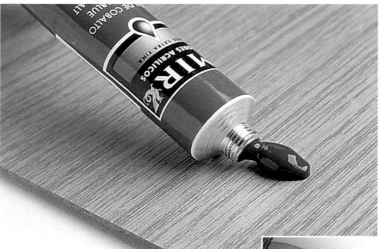

By squeezing the tube slightly, the right amount of paint will be deposited on the palette.

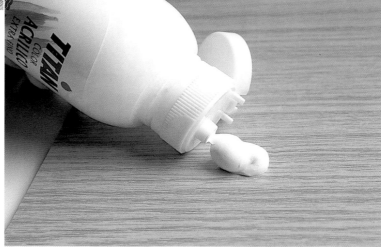

Bottles with a small tip gauge make it easy to control the flow of paint onto the palette.

Types of Mixes

Mixing colors can be done on the palette, in paint wells, or on the canvas itself. The mixes can be physical or optical. The latter type produces the effect of a new color by juxtaposing two colors. This effect gives the work a vibrant appearance.

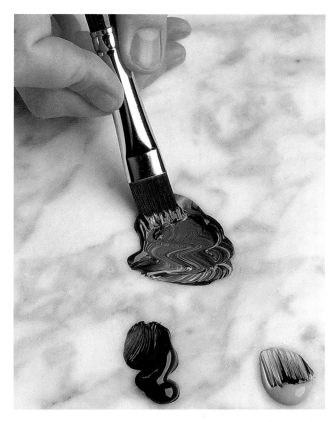

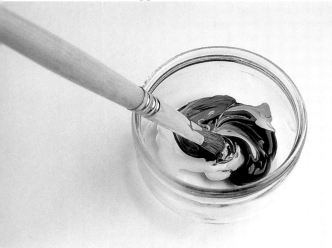

When mixing color for a large area, such as a background, you should use a paint well so there will be enough.

To mix colors on the palette, add a small amount of each of the component colors and mix them together until you have a uniform color.

Optical mixes are done on the support. In this case, the combination of blue and yellow dabs produces a light green.

Another method of mixing colors on the canvas consists of superimposing glazes. To do this, work with transparent colors or dilute the paint, since it is the transparency that alters the tone of the superimposed color.

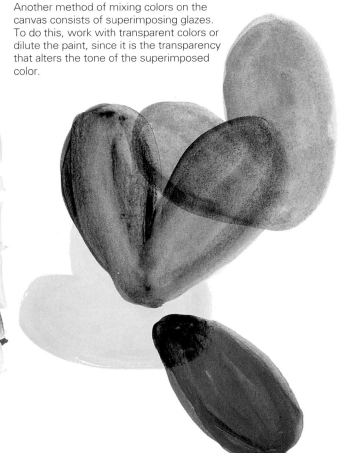

The Transparency of Colors

The characteristics of paint pigments vary from color to color. Certain colors are opaque and can be used for covering backgrounds; others are transparent and leave any underlying lines visible. In addition, there are semitransparent colors.

Transparent and semitransparent colors allow the artist to superimpose glazes. It is usually necessary to dilute the paint and alter the density.

Opaque colors, in contrast, are used primarily for painting backgrounds or making corrections. You should understand the characteristics of each color of your palette in order to get the most out of them and avoid errors. You should also bear this in mind when you are buying paints and test the degree of opacity and transparency of each color before you begin a painting. It is usually best to work from transparent to opaque, because it is easier to cover with opaque if you want to change something as you go along.

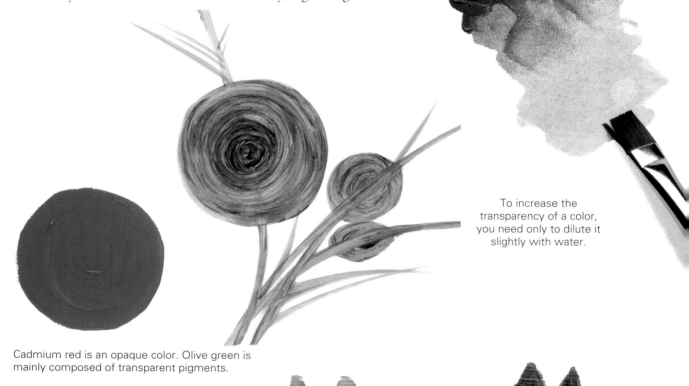

To increase the transparency of a color, you need only to dilute it slightly with water.

Cadmium red is an opaque color. Olive green is mainly composed of transparent pigments.

Emerald green is a semitransparent color. When it is applied thickly, it can have considerable covering powers; applied diluted, its tone changes radically and the paint acquires an appearance similar to watercolor.

Impasto

Impasto is a thick application of paint that creates a relief by rising above the painting surface. Impasto allows the artist to model thick layers of color and create texture. Since impasto reveals the brushstroke, it can also be used for creating special effects and indicating depth and volume.

When using impasto it is important to bear in mind that the drying time will be longer than usual due to the thickness of the paint, and that the artist will use more paint than usual.

Even though many artists prefer to work separately with impasto, thinner layers, and transparent colors, these three techniques can be combined in a single painting to achieve more complex works or interesting senses of volume.

It is possible to superimpose glazes of watered-down colors that still allow the original lines of the drawing to show through.

When impasto is used, the thickness of the paint makes any color more opaque and lets us appreciate the mark of the brush in the paint.

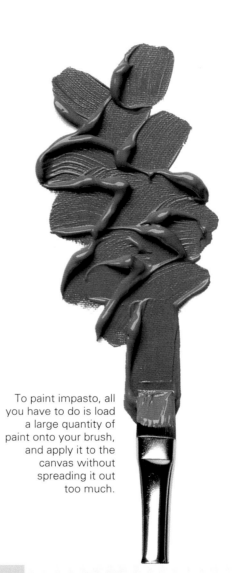

To paint impasto, all you have to do is load a large quantity of paint onto your brush, and apply it to the canvas without spreading it out too much.

REMEMBER . . .

■ Paints can be opaque, transparent, and semitransparent. It is important to understand their characteristics before mixing colors or painting glazes.

Using a Brush

A brush is the most common implement used to spread paint over a canvas; therefore, you should know how to use it properly and keep it in perfect condition for your work.

To paint a free, gestural work, the brush should be held like a wand, since it allows for more freedom of movement.

The brush can also be held as one would hold a pencil, especially for painting details.

How It Is Held

Each artist has his or her own way of holding a brush, although there are two basic ways that all painters tend to use—for painting details it is best to hold the brush as one would hold a pencil; for a freer stroke, it should be held like a wand or a rod.

How Many Brushes Do You Need?

Professional painters have a wide variety of brushes, mainly because they accumulate them over time; but most artists use only a few.

Three brushes are enough to get started in acrylic painting: small, medium, and large; however, you may want a few more to ease the load. You may also want a brush used for house paint. The selection shown at the bottom of this page has brushes that are suitable for painting any subject in both small and large formats.

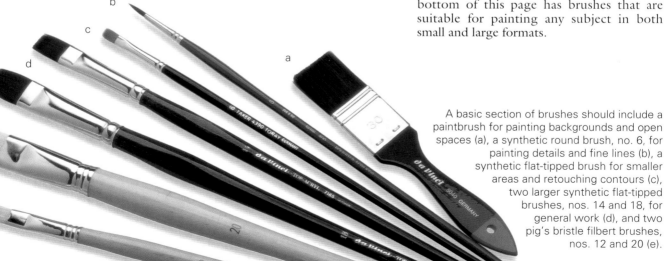

A basic section of brushes should include a paintbrush for painting backgrounds and open spaces (a), a synthetic round brush, no. 6, for painting details and fine lines (b), a synthetic flat-tipped brush for smaller areas and retouching contours (c), two larger synthetic flat-tipped brushes, nos. 14 and 18, for general work (d), and two pig's bristle filbert brushes, nos. 12 and 20 (e).

How to Clean Brushes

It is essential to keep a brush clean if it is to serve its purpose; otherwise, your work will be made more difficult. Always have a rag handy for removing excess water that can accumulate in the hairs each time you rinse between colors. Once you have finished painting, the brush should be washed carefully and then left to dry with the hairs pointing upward so they stay in shape.

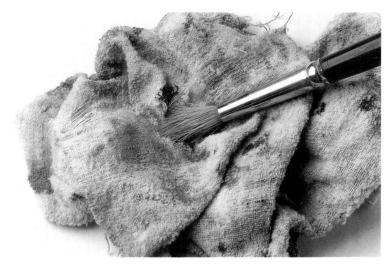

A rag is used to remove the excess water that the brush acquires each time it is rinsed.

1

1. When you finish painting, rinse your brush in water to remove as much remaining paint as possible.

2

2. Then add some soap or detergent and rub the hairs softly against the palm of your hand until it foams.

3

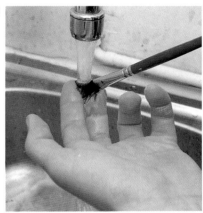

3. Wash the brush under a running tap.

REMEMBER . . .

■ Never allow paint to dry on a brush; this will damage it irreparably.

■ Wash your brushes with soap and water when your painting session is over.

4

4. Remove the excess water and, using your fingers, press the hairs into their original shape.

5

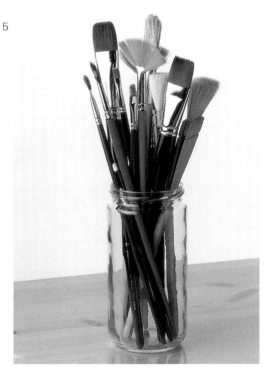

5. Place the clean brushes upside down in a jar so that they stay in their proper shape.

Mounting Canvas

Both canvas and paper, as well as certain types of cardboard, are too flimsy to paint on unless they are attached to an additional support. You should take the time to prepare them correctly before beginning a picture.

Cutting, Mounting, and Stretching

To attach and stretch a canvas on a stretcher it is important to cut the canvas to the right size before stapling. This can be done with a knife or a pair of scissors, leaving a two-inch margin of canvas around the stretcher.

The canvas is attached to the stretcher using a staple gun, although some painters prefer to mount their canvases using a hammer and nails.

Pliers or tongs are used to hold and stretch the canvas as you mount it on the stretcher. Smaller canvases can be mounted without these tools, but we suggest you always use them to get the best results.

The best technique for mounting canvas without producing creases is by fastening down all sides at the same time. You do this by attaching the canvas to each one of the sides with a single staple in the center, then working toward the corners. Every time you staple one side, do the same to the opposite side, and finally with the remaining two sides.

To finish, fold the canvas over at the corners and staple it down.

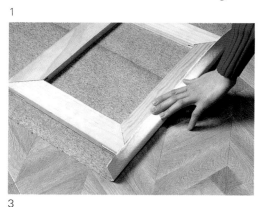

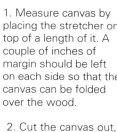

1. Measure canvas by placing the stretcher on top of a length of it. A couple of inches of margin should be left on each side so that the canvas can be folded over the wood.

2. Cut the canvas out, leaving the same margin around the entire frame of the stretcher.

3. Staple the center of any side.

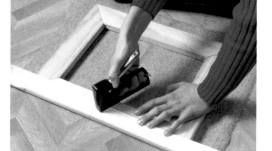

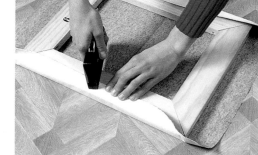

4. Then staple the center of the opposite side, tightening canvas as you work.

5

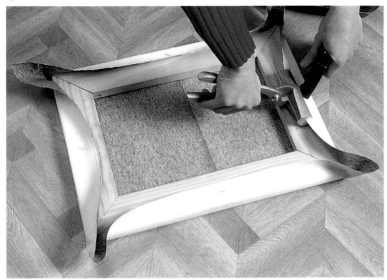

5. Follow the same procedure for the other two sides. If you are using a large stretcher it is best to work with pliers.

6

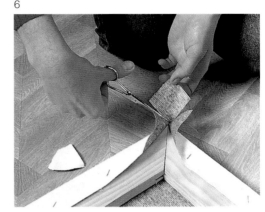

6. Staple the canvas from the center to the corners by alternating sides in order to avoid creases. Then cut the corners.

7

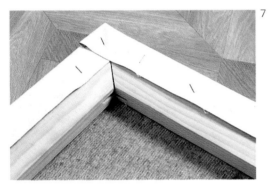

7. To finish, fold the corners down and staple them.

Other Supports

The stretcher can also be used for tensing paper or stiffening wooden boards, such as plywood, that warp with time. Paper can also be attached to a board.

Plywood boards can be attached to a stretcher with nails to prevent them from warping over time.

■ You must mount flimsy supports such as canvas or paper on a board or stretcher if you want to paint comfortably.

■ To further tense a canvas that has already been mounted on a stretcher, you have only to wet the reverse side and wait for it to dry.

Paper can be mounted on a board with tacks, clips, or adhesive tape. Tape can also be used to preserve the color of the paper around the border; it will leave a clean margin when it is removed.

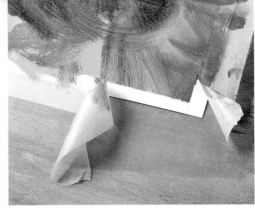

Priming the Support

Even though acrylic paint adheres relatively well to canvas, unprimed canvas or paper may get soggy.

1. First, mount the canvas on a stretcher, then make up a solution of gesso and water in a container.

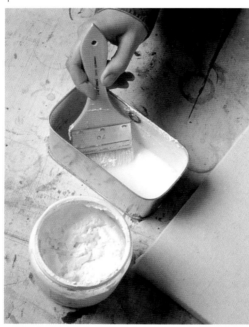

Priming Canvas

Priming canvas involves applying a special layer over the surface so that you can paint on it. Although many artists paint on unprimed canvases, priming the surface beforehand provides a protective separation between the canvas and the paint which prevents too much water from being absorbed.

Canvas for painting in acrylic can be bought either ready-primed or raw, that is, without a layer of priming. In that case, the artist normally primes it with gesso, latex, or other materials sold for this purpose, although the canvas can be painted on just as it comes.

When choosing a ready-primed canvas, make sure that the priming is appropriate for acrylic, as canvases prepared especially for oil contain a greasy component that prevents synthetic paints from adhering properly to the surface.

2. The first layer should be relatively thin and must be applied in a single direction.

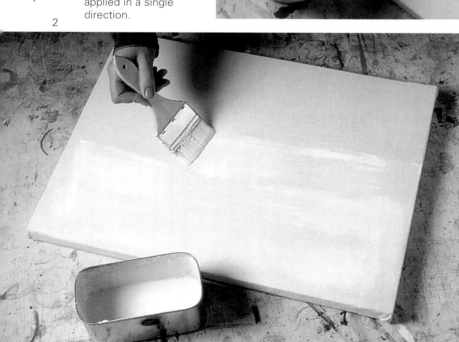

3. The second layer of gesso should be thicker and applied in the opposite direction to the first in order to fill in any crevasses that may have been left uncovered in the first layer. You can apply as many layers of gesso as you think necessary, although two or three should be sufficient.

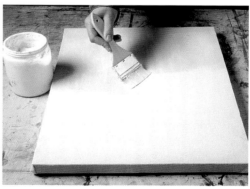

Priming Other Supports

Wood, paper, and cardboard can also be primed to prevent the paint from soaking through the surface.

The products and techniques used for priming these supports are the same as those used for priming canvas. The first layer should be applied in a diluted form, while the following ones should be thicker.

Paper should be attached to a board with adhesive tape prior to priming to prevent it from creasing from the dampness.

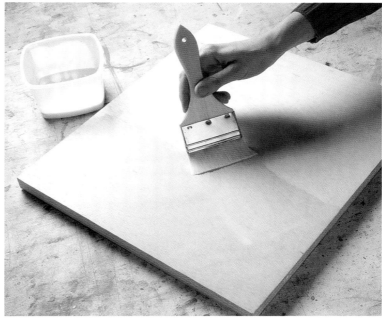

Painters can use latex for priming the surface of a wooden board whose color they wish to preserve, since this substance becomes transparent once it is dry.

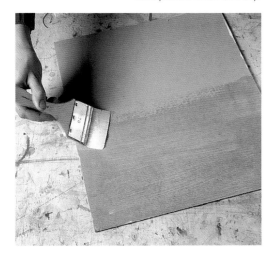

Cardboard is primed to prevent it from curling up when it absorbs too much water.

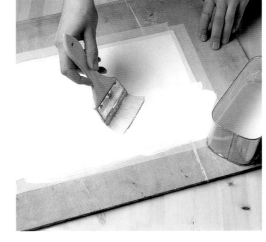

To prime paper, it is best to first mount it on a board, since the dampness of the gesso or latex will cause it to curl and crease.

Once a layer of priming has dried, it can be sanded down with a piece of fine sandpaper to the texture you want.

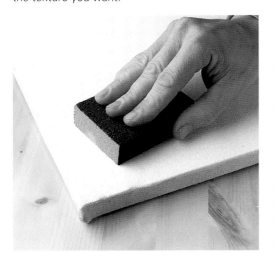

Wedges are inserted between the corners of the stretcher to increase the tautness once the canvas has been mounted and primed.

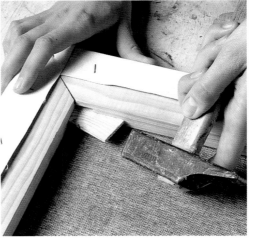

REMEMBER . . .

■ You should apply the first layer of priming in a semidiluted state so that it penetrates the weave of the canvas.

Using a Palette

The palette is an indispensable part of a painter's equipment, because most of the colors are mixed there and it holds the paint as the artist works.

Arranging the Colors on Your Palette

There are many ways of arranging colors on the palette and each artist has his or her own preference. Some prefer to group them into ranges of cold, warm, and neutral; others have no special order. To find out which method is best for you, you must try out various ways and choose the one that suits you best. The one thing we do advise you to do is to separate your black and white paint from the other colors; white has to be protected from getting dirty; black can contaminate the other colors.

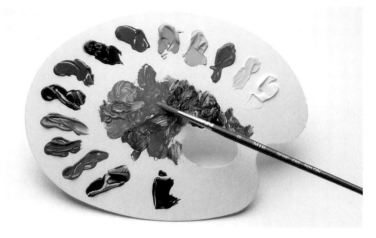

The paints are placed around the edge of the palette, leaving the main area for mixing. Some painters always put their colors in the same order on the palette so that they can reach instinctively for the right one without having to look for it.

A palette allows painters to avoid loading paint directly from the tube onto the brush, contaminating the color.

How Many Colors Should I Put on My Palette?

Since acrylic paint dries fast, unused paint quickly forms annoying hard lumps on the palette that cannot be salvaged. To avoid waste, you should not put all of your colors on the palette at the same time unless you are going to paint very fast and are planning on using them all. If you are unsure about which colors you are going to use, the best method is to place only those you are certain of on the palette and add the others as the need arises.

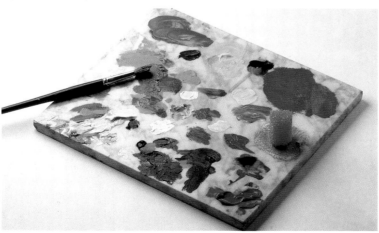

Since acrylic paint dries very quickly, you should put paint on your palette only as the need arises. Each painting often requires a different range of colors so you should not worry about arranging them in any particular order.

Cleaning the Palette

Once acrylic paint has dried it cannot be rehydrated; therefore, it is important to clean the palette when a session is over or when it is too dirty.

The best palettes are made of polished glass or plastic, since such nonporous surfaces allow paint to be removed easily.

Wooden palettes may be attractive but may create problems due to the porosity of the surface, as paint tends to get stuck in the grain of the wood and can't be removed.

Once paint has dried on the palette, the only way to remove it is by using a knife.

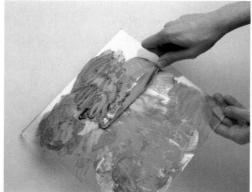

1. When a painting session is over, the remaining wet paint should be removed from the glass palette with a palette knife.

2. Dried paint should be removed with a knife before the palette is washed with water.

1. If you forget to clean the palette after a session—especially if it is a wooden one—the dry paint will form hard lumps. In that case, the only way to remove them is with a knife.

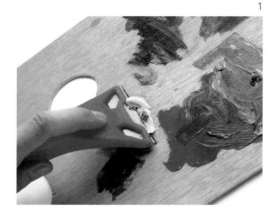

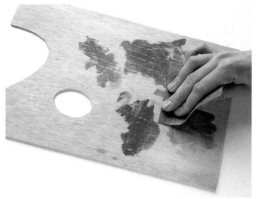

2. Once the lumps of paint have been removed, smooth down the surface with sandpaper.

A plate, a tray, a formica cupboard door, a pane of glass, a frozen dinner tray, or any other type of smooth surface can serve as a palette when needed.

REMEMBER . . .

■ Acrylic paint dries very quickly so you should not put all your paint on the palette at once, but only those colors that are needed.

■ You should clean your palette after each painting session.

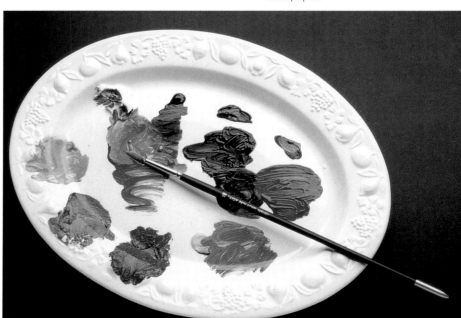

Drawings

Although drawing is an art in and of itself, it is also used as a preparation for painting because it allows the artist to study a subject in depth and situate forms within the canvas.

Drawing

Drawing is a fundamental part of the painting process; it allows the artist to study a subject in depth and analyze its volumes and forms.

Before a painter begins any type of picture, he or she should draw or sketch the subject on a separate sheet of paper. These small studies can be done in black and white, using graphite or charcoal, or with a touch of color applied with acrylics in some of the colors the artist intends to use in the final painting.

In addition to these preliminary studies, the acrylic artist often sketches the subject on the canvas in order to distribute the forms within that space.

Some painters merely suggest the forms with a few strokes; others prefer to draw a more elaborate outline, including shadows and details.

If you have not mastered the art of drawing, it is best to sketch the figures using geometric forms, leaving the outlines for later.

Sketching the subject directly is a good way to study it. These sketches provide the artist with information about tones, forms, and even colors, which can later be applied to a full-sized canvas.

1

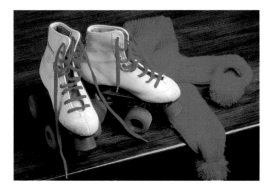

This subject is made up of a pair of roller skates and a scarf. Once the arrangement of the objects has been chosen, the drawing begins.

2

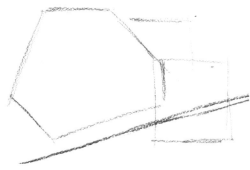

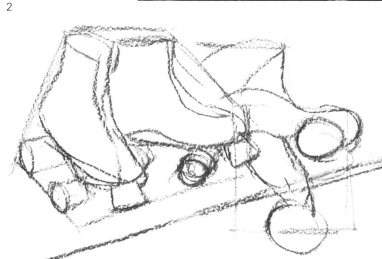

1. The main shapes of the objects can be arranged in the space in the form of geometric shapes.

2. Then the forms of the actual objects can be brought out from within the geometric shapes. This second stage advances you enough to begin painting, although many artists prefer to elaborate the drawing still further.

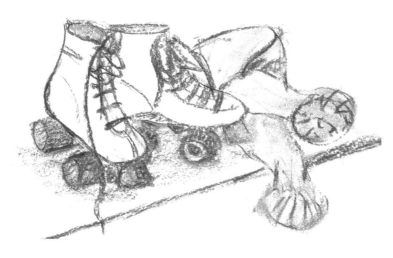

3. Once the outlines have been set down and the extra lines removed, the drawing is finished.

Projecting an Image

If a painter has not mastered drawing techniques, or when the subject is rather complicated, a preliminary sketch can be developed by projecting the image onto the support.

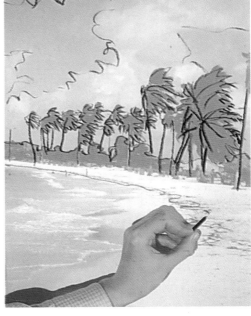

The image is projected onto the canvas or paper, then the artist goes over the lines in charcoal or pencil.

Erasing or Fixing

Charcoal leaves a very intense mark and can dirty the colors that are applied on top; therefore, many painters remove excess charcoal dust with a brush or protect the charcoal with fixative.

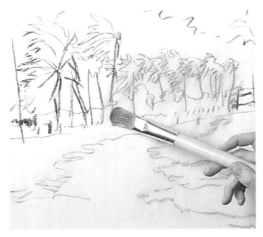

The excess charcoal dust is removed with a dry brush or rag; this method leaves faint lines that are used as guides for applying the paint.

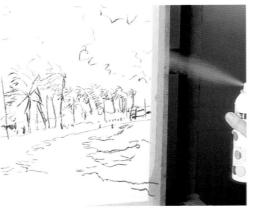

If the artist wants the lines to remain sharp when he or she paints over them, all that needs to be done is to apply some fixative to prevent the charcoal dust from coming loose.

REMEMBER . . .

■ Preliminary drawings are essential for successful results in your paintings.

■ Always sketch your subject before beginning the final painting.

One Color

Before we examine the subject of color, we should familiarize ourselves with the problems of variations in light that create an endless variety of tones.

Tones

To develop a range of tones with one color, you can mix white with it in ever-increasing amounts until it becomes almost white.

Tones are the variations in intensity of a color from light to dark.

Tones allow the artist to render volume because it is precisely the contrasts in light that suggest the third dimension.

In acrylic painting there are two ways to create a tonal range from one color: adding white to make the light tones and black for the dark ones, or diluting the color with water.

Neither system is better than the other, it all comes down to necessity. When a color is diluted, it becomes transparent or semi-transparent; therefore, diluted colors are useful for painting glazes. Adding white to the color, on the other hand, produces an opaque color. It is important to bear in mind that this method produces other changes as well. Red, for instance, becomes pink when white is added to it; yellow blended with black takes on a greenish hue.

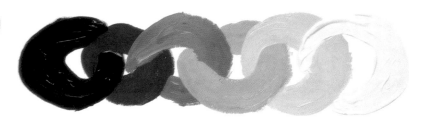

By adding water to paint, we can lighten the tone of the color—the more water added, the lighter and more transparent the color.

Some colors change altogether when mixed with black or white. In this case, yellow turns green due to the addition of black; when mixed with white, this yellow eventually loses all trace of its original color and becomes white.

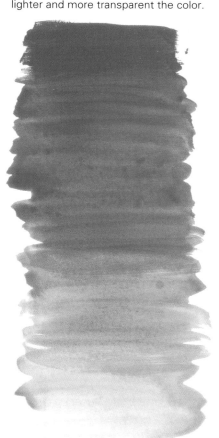

REMEMBER . . .

■ You have to work fast when creating gradations of a color or it will dry before you get the desired effect.

■ When you vary gradations of a color, always stroke in the same direction with the brush so that the dark tones won't mess up the light ones you have just finished painting.

Gradating with White

Gradations are most commonly used to paint skies, stretches of water, or undefined shadows, so it is useful to know how to perform this technique. It is difficult to gradate with acrylic paint, since the paint dries very quickly and there is barely enough time to blend one color with another. There are many ways to gradate; each artist has his or her own way of going about it. The procedure demonstrated on this page is the most suitable one for beginners.

1

1. Paint a thick line of the color you wish to gradate.

2

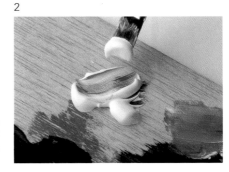

2. Next load a little white onto your brush and mix with the previous color to make a lighter tone.

4

3. Paint another line with this tone.

3

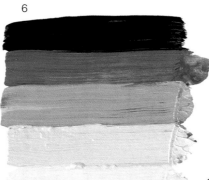

4. Remember to remove any excess paint from the brush in order to continue developing lighter tones.

5

6

6. Continue repeating the operation with ever-paler tones. The number of stripes depends on the painter—the more subtle the result desired, the more stripes necessary.

5. Now apply a new tone. Don't forget that this procedure must be carried out as quickly as possible in order to finish before the paint dries.

7

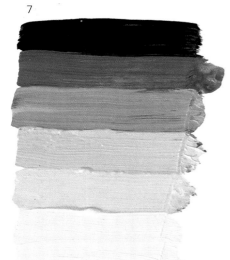

7. To finish, paint a thick patch of pure white.

8

8. With a clean brush, "comb" the surface sideways from top to bottom in order to gradate the color. Don't go back with the brush or you will ruin the effect of the gradation.

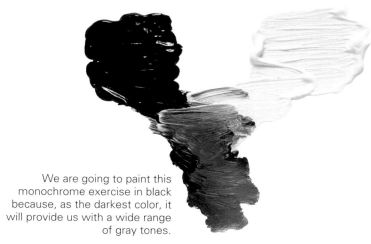

We are going to paint this monochrome exercise in black because, as the darkest color, it will provide us with a wide range of gray tones.

Painting in Black and White

The best way to practice painting in acrylics as well as to study light is by doing several exercises in black and white, since this forces the artist to rely on tones rather than colors to suggest volume.

One way of seeing the various intensities of a subject consists of looking at it through squinted eyes. This method allows you to see the volumes as patches of light, dark, and intermediate tones.

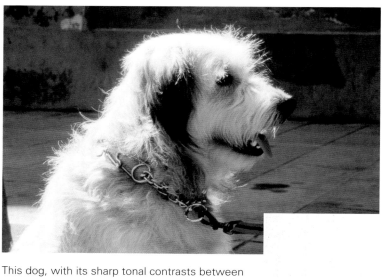

This dog, with its sharp tonal contrasts between light and dark, is our subject.

1. The first step is to sketch the dog, using a pencil or a fine-tipped brush, in order to situate it correctly on the canvas.

1

2

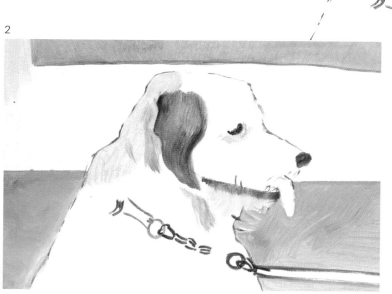

2. Continue by painting the background. Its dark tones will contrast nicely with the brightness of the dog.

3. Next, fill in the dog with a light gray that will serve as a base color to bring out the hair.

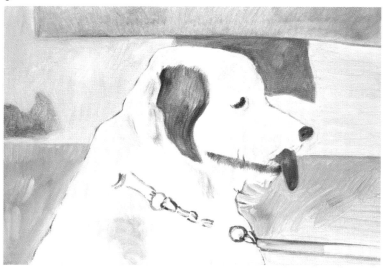

3

4

4. Paint the hair and suggest its texture by means of short curving brushstrokes.

5. In theory, the exercise is complete, but closer observation reveals there is something wrong. When we compare it with the actual model we can see that there is not enough contrast between the dog and the background.

5

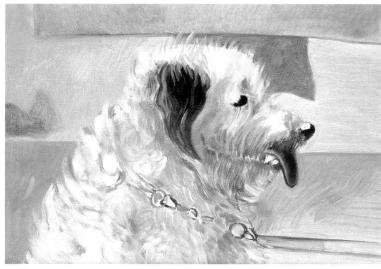

REMEMBER . . .

■ It is important to pause and compare the actual subject with the painting. This will help to prevent errors like the one made in this exercise.

■ Acrylic paint dries very quickly. If you do happen to make a mistake, don't worry; just wait for the paint to dry, then make your corrections.

6

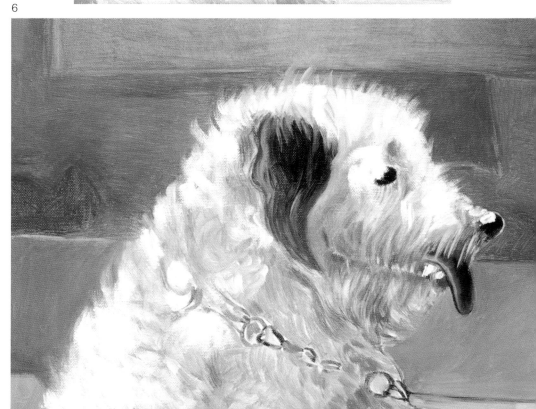

6. The error is corrected by darkening the background with black glazes. Now the dog appears to stand out from the background and we get a more realistic sense of volume.

Various Colors

A limited but carefully chosen palette allows the beginner to paint any subject without getting lost in a sea of colors.

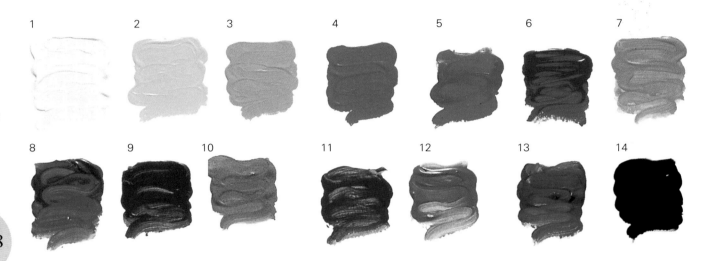

1. Titanium white
2. Cadmium yellow
3. Orange
4. Cadmium red
5. Crimson
6. Violet
7. Yellow ocher
8. Burnt sienna
9. Raw umber
10. Emerald green
11. Olive green
12. Cerulean blue
13. Cobalt blue
14. Ivory black

A. Cadmium yellow
B. Crimson
C. Cerulean blue

A Suggested Palette

You don't need a wide range of colors to get started painting in acrylics. A limited palette is easier to handle and still allows the artist to paint any subject. Also, with this type of palette the painter must mix colors, an exercise that acquaints him or her with the world of color. Later on, as you become more familiar with and begin to master color-mixing techniques, you will see how the colors that are not included in the palette can be obtained through blends. This experience will allow you to increase your range and personalize your palette.

Primary and Secondary Colors

The three primary colors—yellow, red, and blue—are included in the palette shown on this page. These three colors are fundamental because, by mixing them together, we can make all the colors of nature. It is even possible to paint an entire picture using only these three colors.

The secondary colors—orange, green, and purple—are those produced by mixing two of the primary colors together. By combining primary colors with secondary colors, we get tertiary colors. The blending of secondary and tertiary colors produces even more colors. Although it is possible to produce any color using only the three primaries, artists work with more prepared colors to save time, since the most commonly used colors are available on the market.

A

B

C

Mixing cerulean blue and cadmium yellow produces green.

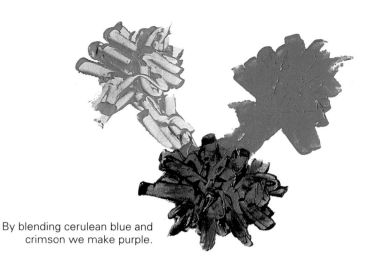

By blending cerulean blue and crimson we make purple.

The secondary color orange can be produced by mixing the primary colors yellow and crimson.

In theory, mixing the three primary colors produces black, although in practice it tends to produce a very muddy gray.

Complementary Colors

Complementary colors are those that, when juxtaposed, produce an extreme color contrast. They come in handy for creating vibrant images and striking contrasts.

REMEMBER . . .

■ Although the three primary colors can be used to produce any other color, most artists use other prepared colors to avoid having to make basic mixes.

The complementary of cobalt blue is a dark orange.

Yellow produces the greatest contrast when it is placed next to purple.

Green and crimson are complementary colors.

Procedure

Although each artist has his or her own way of working, there is a common painting procedure that is very useful for painting in acrylic.

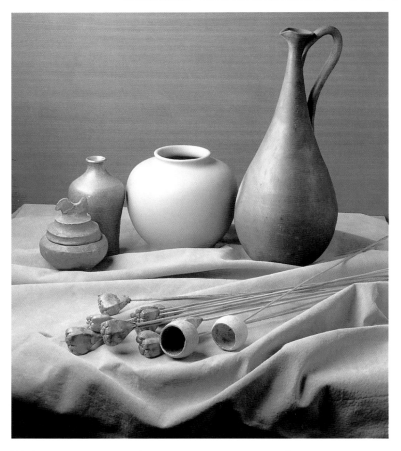

Painting Step by Step

Watercolor painting is normally done quickly in order to take advantage of the dampness of the paper and avoid breaks in color. Because of the slowness with which oil paint dries, the painter must wait several days to rework an area or correct something; acrylic paint dries quickly like watercolor, but is applied as thickly as oil. These two characteristics allow us to work at our own pace, make corrections easily, and paint in layers, since it is not necessary to wait for the background to dry.

Procedure for Painting a Still Life in Acrylics

The procedure for painting in acrylics is very similar to painting in oils, with the difference being that acrylics can be superimposed in layers without the danger of the colors bleeding together, since the paint dries very quickly.

We have set up as our subject this still life of several vases with some wooden flowers in the foreground.

Seven colors are used to paint this still life: white (1), orange, (2), yellow ocher (3), burnt sienna (4), cobalt blue (5), olive green (6), and black (7).

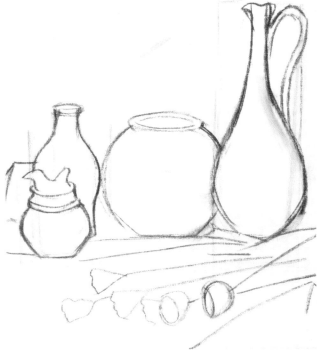

1. We first structure the space into geometric areas to begin our drawing.

2. The division of the space from the farthest away to closest allows us to draw the forms more easily.

3. We trace the charcoal lines with acrylic paint so we don't lose them once we begin painting the canvas; for the same reason, we paint each object in its own color.

4. The background is now painted with semidiluted yellow ocher so it's not too dark.

3

4

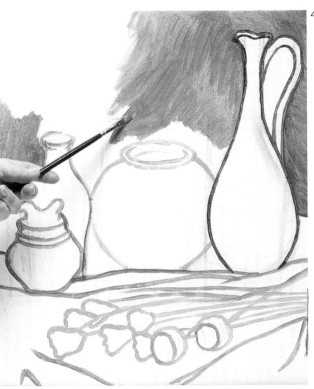

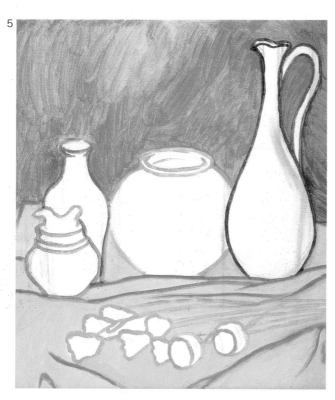

5. Then we paint the tablecloth, hinting at the lines of the creases and the stems of the flowers.

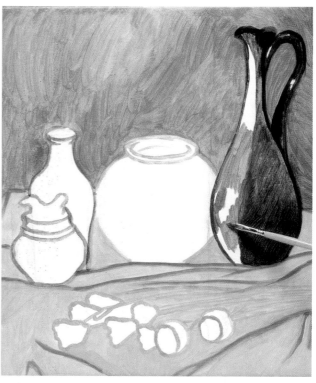

6. We begin to paint the tallest vase with black mixed with cobalt blue in the darkest part and several gray tones for those areas in direct light.

7. Using the previous procedure, we paint the other vases with their main tones, but darken very slightly those areas that need it. As you work, you will see the areas of light and shadow gradually emerge.

8. When the entire canvas is covered with paint, we can see that the background appears too light; we darken it with burnt sienna, a transparent color.

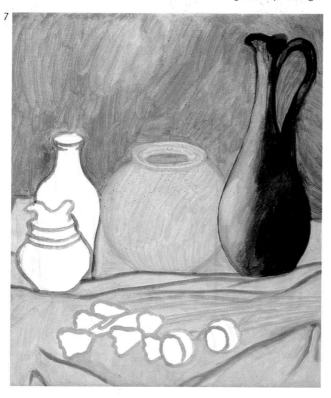

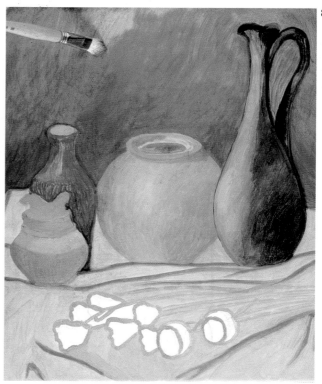

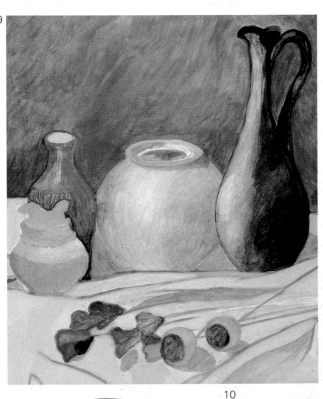

■ A drawing is the first step on the road to a successful painting, since it allows the artist to situate the objects within a space and determine the forms and proportions.

■ The final stage of a painting consists of highlighting and correcting highlights and shadows. In other words, it is the moment when the artist suggests the volume of the forms.

9 and 10. This is the finished work. Notice how it differs from the previous stage. The objects have been given depth. The creases and folds of the tablecloth have been elaborated by including more shadows and lightening other parts with an orange glaze. The change in the vases is also notable because their volume has been increased by darkening their shadows.

10

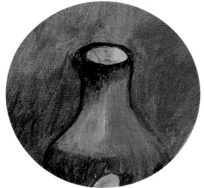

This detail of the vase reveals how the color contrast between the interior and the exterior part produces a three-dimensional effect.

The technique used for the vase is also used on the flowers, but this time a dark color is applied to the interior and a light one to the outside.

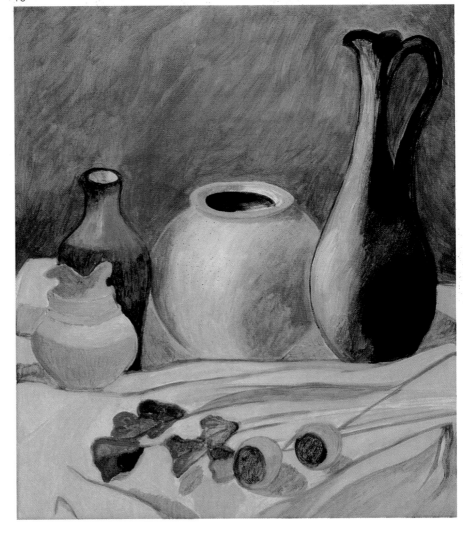

Basic Techniques

43

Acrylics

Using Impasto

Impasto, a thick application of paint, produces a certain amount of relief by rising above the surface of the painting. It allows the artist to create textures by modeling it as if it were paste.

Nine colors are needed to paint this picture: cadmium yellow (1), orange, (2), cadmium red, (3), yellow ocher, (4), raw umber (5), olive green (6), emerald green (7), and violet (8).

Impasto

Impasto is an important technique in acrylic painting that helps the artist suggest volume and texture. Although certain artists work in this way, using impasto does not imply filling in the entire canvas with thick chunks of paint. Most painters limit themselves to using impasto only in those parts of the picture where it is necessary.

Painting a Hyacinth

We have set up a still life whose depth is divided into three clearly defined planes: the hyacinth, the brick, and the

We have removed the hyacinth from its pot for this work in order to contrast its vertical roots with the horizontal lines of the cardboard background and the brick.

1. Begin by painting the background, making sure to stay within its limits. The left side has been painted with a thick layer of paint; the area on the right with one even thicker. The brick is also painted using impasto. At the same time, take advantage of the stroke to model its surface texture.

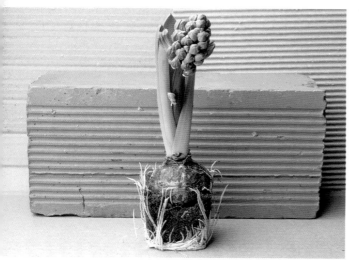

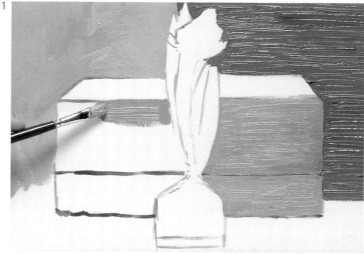

2

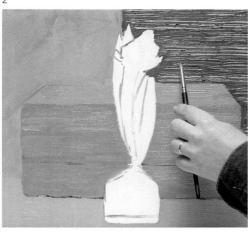

2. With a rubber-tipped brush, create horizontal lines in the still-wet paint to convey the undulations in the cardboard background.

3

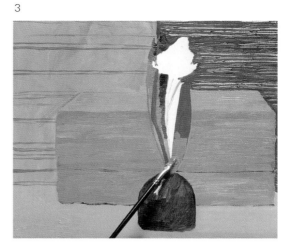

3. Now, paint the hyacinth, still using a large amount of paint but in a much thinner layer than that of the cardboard background.

background. Impasto allows the painter to create textures and interesting three-dimensional effects.

To model the paint, we use both the marks left by the hairs of the brush and the sgraffito technique, that is, scratching lines and furrows into the surface layer of wet paint.

4

4. We add several thicker applications of paint over the first layers painted over the hyacinth. This gives the plant shape and brings it nearer to the spectator.

5

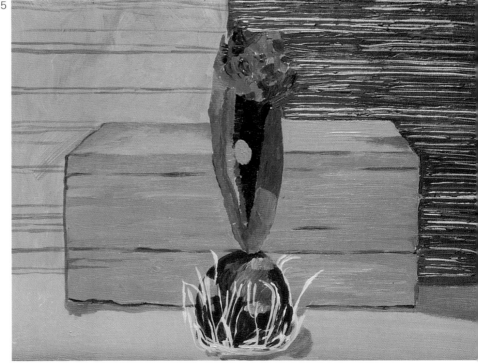

5. In the finished work, we can appreciate that, although the thickest paint was applied in the background, there is still a sense of depth in the entire painting, since the treatment of the hyacinth and the use of shadows heighten the three-dimensionality of the whole.

Painting with Glazes

Acrylic paint can be diluted in water and used the same way as watercolor. You can apply a thinned layer of color as a glaze to add interest to your painting.

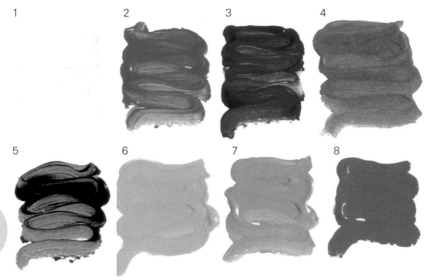

Eight colors are needed to paint this picture: white (1), cerulean blue (2), cobalt blue (3), emerald green (4), olive green (5), orange (6), yellow ocher, (7) and cadmium red (8).

Glazes

A glaze is a transparent film of paint that allows underlying colors to remain visible. It can also be used to create color mixes. Glazes give a delicate character to pictures because they allow forms and colors to be suggested with subtlety.

Although they are easy to apply to canvas, the ideal support for very diluted transparent glazes is paper or cardboard, which are absorbent.

Painting Nets

Anything in nature can be interpreted in an abstract form that changes the most simple objects or least suggestive images into

The model we have chosen for this exercise is a fragment of fishing net placed on a bed of small flowers; the framing of the image is quite abstract.

1. Since glazes are transparent, we do not draw a preliminary outline of the model with charcoal but with color. This prevents unwanted lines from remaining visible under the paint.

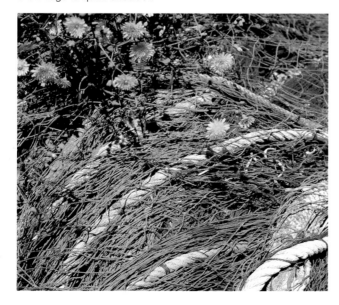

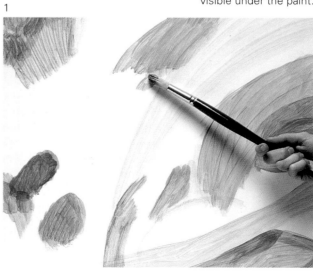

subjects that assume a new importance because of the artist's treatment.

This exercise will be painted on cardboard, as it absorbs diluted paint nicely.

The fishing nets are placed outside their normal context and framed in such a way that, although still figurative, they seem closer to an abstract image.

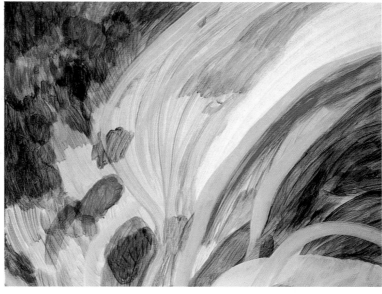

2. In the first pass we covered the whole canvas, bringing out the forms with transparent paint rather than lines. You will notice how thin layers of color have already been painted over the first applications, changing the intensity and hue of the colors.

3

3. Once the basic image has been created with superimposed glazes, we use opaque paint to start adding flowers.

4

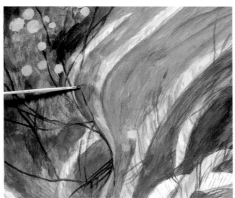

4. We have decided to adjust the general hue of the work by adding cobalt blue glazes. Once they are dry, we can add the wavy lines that suggest the netting.

REMEMBER . . .

■ Glazes can be painted on canvas, especially if the color is diluted with acrylic medium or a similar substance; cardboard absorbs better and is often more suitable for use when the paint is only diluted in water.

5

5. In the finished work, we can observe how the feeling of depth, disorder, and superimposed netting have been obtained by the application of successive layers of transparent paint.

Painting with Stencils and Masks

The use of stencils or masks in a painting involves a certain amount of planning, since they need to be prepared beforehand to make the brushwork easier.

Eleven colors are needed to paint this picture: white (1), cadmium yellow (2), orange (3), cadmium red (4), crimson (5), yellow ocher (6), burnt sienna (7), burnt umber (8), emerald green (9), cobalt blue (10), and black (11).

Making Stencils and Masks

Masks can be made out of any type of material that is resistant to the dampness of paint and does not tear or rip when rubbed with a brush. Generally, they are made of cardboard or thick paper, since these materials are easy to cut and can be given virtually any shape.

Painting a Still Life with Stencils and Masks

When you paint with stencils, you should choose an object that does not have complicated forms that make it difficult to cut out.

1. We begin by placing a large rectangular stencil over the canvas, attached with three strips of adhesive tape. We apply crisscross strokes of paint to its center.

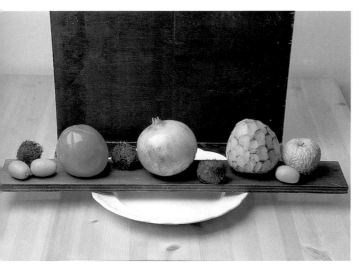

We have chosen this still life for the exercise because of its straight lines and simplicity of form.

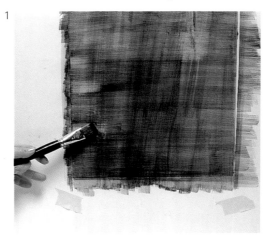

1

2

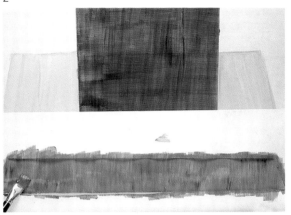

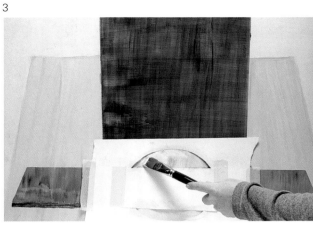

3. The stencil used for the plate is a simple circle. In order to prevent the paint from penetrating the area of the board, we mask it with a thick strip of cardboard applied to the center so that we can work in comfort.

2. We have used a stencil similar to the one in the previous step. It is useful to note that due to the presence of the stencil, the brushwork can overlap the limits of the object and still produce hard edges.

4

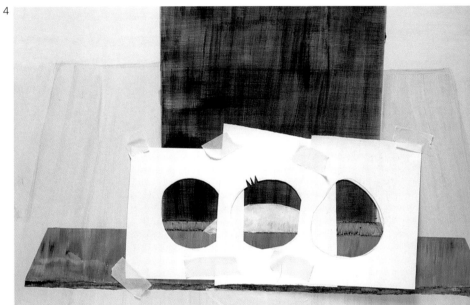

4. Now we cut out the three stencils for the fruit, placing one behind the other to be sure they are placed at the correct distances from one another. Obviously, in order to paint the cherimoya, a tropical fruit, the pomegranate stencil will have to be removed.

5

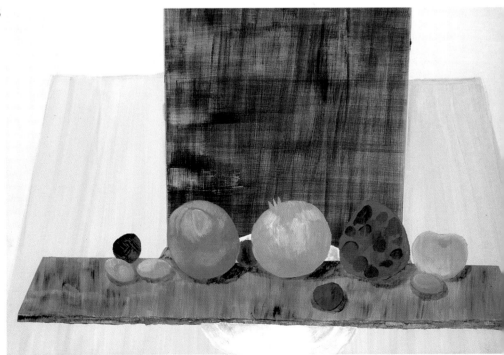

■ Stencils and masks must be made out of materials that are resistant to dampness and the friction of the brush, but they must also be flexible enough that forms can be cut out with relative ease.

5. The last phase of the painting involves painting in the textures and shadows over the base colors of the fruit. Note how the direct brushstrokes painted over these same areas of color do not overlap the contour; this is due to the fact that they were painted with the stencils on top.

Painting with Other Implements

The brush is the most commonly used painting implement, but artists don't limit themselves to it for applying paint.

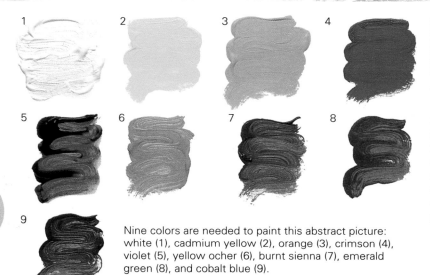

Nine colors are needed to paint this abstract picture: white (1), cadmium yellow (2), orange (3), crimson (4), violet (5), yellow ocher (6), burnt sienna (7), emerald green (8), and cobalt blue (9).

Other Implements

When we speak of other implements, we are referring to anything that can be used to apply color to the support or leave a mark on it. This could be the artist's own finger, a kitchen scrubber, a bath sponge, the cap of a tube, a potato sliced down the middle, or the sole of a shoe; the adventurous artist can make use of many different objects to create textures in the paint.

1. Having drawn the outlines of the shapes, we paint in the background with a rough sponge that leaves the marks of thousands of tiny lines.

1

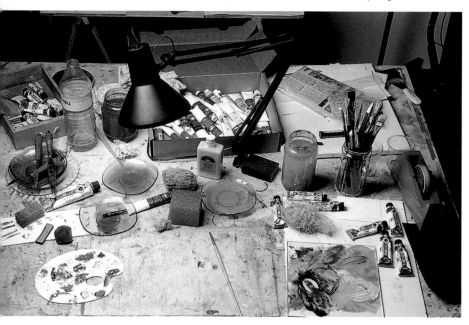

In this photograph of an artist's work table, we can see how the artist has used saucers and palettes of color to fill the sponges.

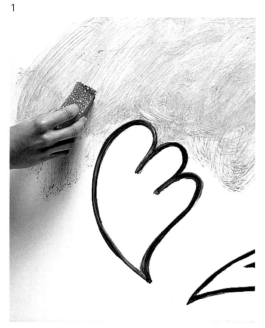

2

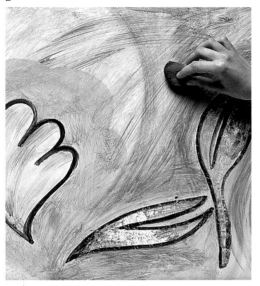

2. We paint the blue shape with another very soft sponge, and apply a violet glaze over the already-dry background.

3

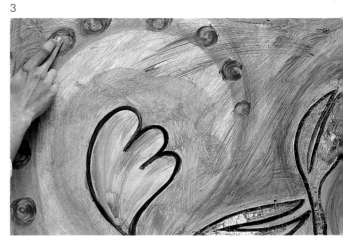

3. We paint the small snail forms with a finger loaded with burnt sienna.

4

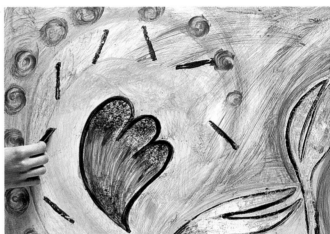

4. The scrubber used for the green forms and for providing texture to the blue area leaves a dotted mark. We use a piece of fine sandpaper to paint the small, imprecise straight lines.

Painting without a Brush

Although it is possible to paint any object of nature without the use of a brush, we have chosen to paint an abstract exercise in which the forms, colors, and volumes are the result of the painter's imagination, since many artists use acrylic to paint nonfigurative themes.

REMEMBER . . .

■ Experimenting with implements other than the brush, or using several together, increases an artist's creativity and widens his or her knowledge of acrylic technique. The artist will also discover interesting and evocative effects.

5

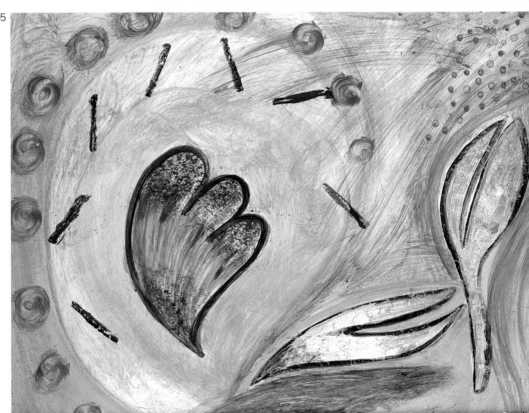

5. In the finished work we can see how the different marks made by the various implements merge together in perfect harmony.

Tricks of the Trade

So-called tricks of the trade form part of the art of acrylic painting and help to enhance the artist's creativity, both in creating textures and effects, and in making corrections.

Making Corrections

One of the great advantages of acrylic paint is its opacity and its fast drying time. These characteristics allow the artist to make corrections during the entire painting process—all you need to do is wait for the error to dry, and then paint over it.

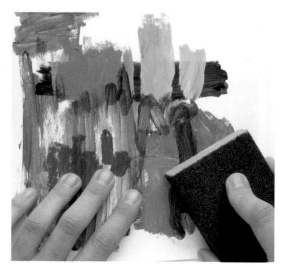

1. Halfway through a painting, the artist sees he or she doesn't like one of the three cattails and decides to correct it.

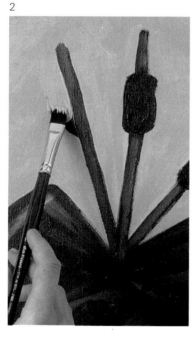

2. The artist paints over part of it with the same color as the background.

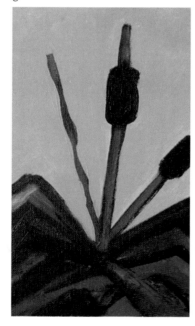

3. The result is a more twisted cattail to which details can now be added.

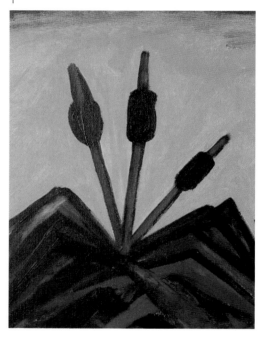

If an artist wishes to remove an area of impasto, it is done by carefully smoothing down the surface with sandpaper.

Sgraffito

In sgraffito, one removes wet paint from the canvas by scratching it off. This is a commonly used technique for creating textures or giving a painting more interest. In the acrylic medium, sgraffito can be done with a palette knife or a handle of a brush, but it should always be done quickly in order to finish before the paint dries.

1. Over an already-dry orange background, we apply a layer of blue.

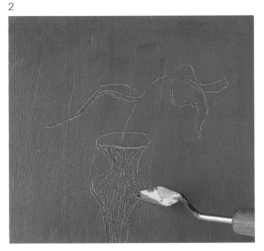

2. Immediately afterward, we scratch in the forms with the tip of a palette knife.

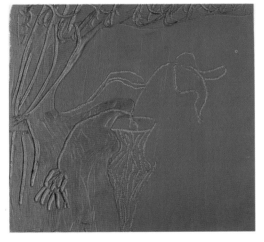

3. Once the blue background has dried, we apply a new layer of orange, and once again scratch away the paint to develop an interplay of contrasts.

Dry Brushing

The dry brushing technique consists of loading a dry brush with paint and then rubbing it lightly over the canvas in circular movements. This procedure is very useful for painting clouds, mist, and any type of rough textures. See Water, pages 56–57 and Skies, pages 58–59.

1. We load a very light gray composed of white, blue, and a touch of black.

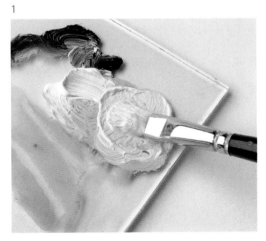

2. The silhouette of these mountains on a dark night is painted and then left to dry.

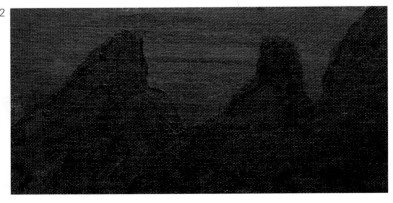

3. We remove any excess paint from the brush on a separate piece of paper.

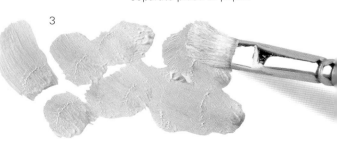

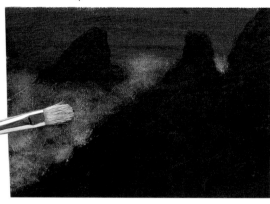

4

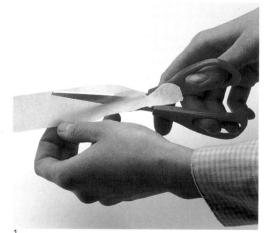

5

4. We softly apply the color with circular movements, holding the brush almost parallel to the canvas.

5. Finally, using the dry brushing technique, we create the mist between the mountains to produce this ghostly landscape.

Preserving with Tape

Preserving an area with tape produces very similar results to those obtained with masks (see Painting with Stencils and Masks, pages 48–49), the only difference being that adhesive tape sticks firmly to the support so there is no danger of it moving. The only drawback to using adhesive tape is its thinness and length.

Despite this, the artist can use tape to create many special effects.

1. The tape is cut into a wavy shape.

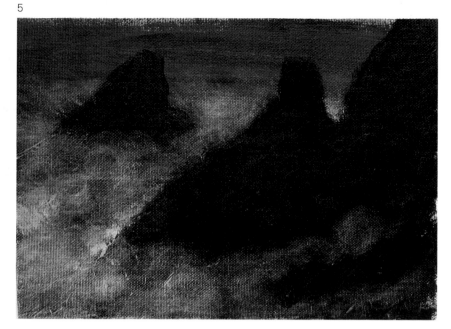

1

2. The strips are attached to the paper and a green glaze is applied; then the tape is peeled off.

2

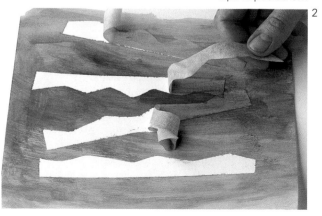

3

3. Once the background is dry, new strips are stuck down and a new layer of very diluted magenta is applied.

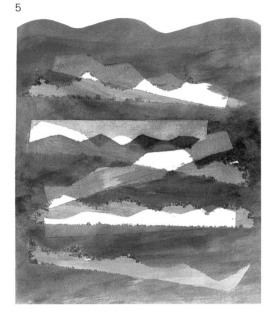

4

4. Once the tape is removed, we can see how the pigment has expanded underneath. This is a result of the quality of the paper and the amount of water with which the color was diluted. If sharper lines are preferred, the paper will have to be primed beforehand.

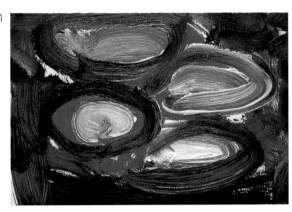

5. This interesting image seems to convey the swells of the sea.

Pulling

Pulling is a technique used to reduce the thickness of an area of paint by lifting it away before it has time to dry. It can also be used to create hazy effects if you move around the material absorbing the paint. Pulling must be carried out on wet paint and executed quickly before the paint dries.

1. The impasto is applied.

2

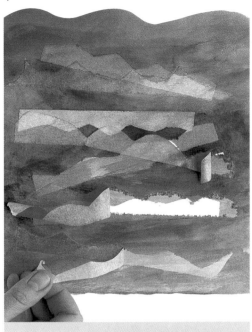

2. Quickly, before the top layer has dried, we apply a sheet of newspaper over the painting and, while pressing down, move it slightly to one side.

3. On removing the newspaper, we can see how much of the paint has been absorbed, and how the forms have lost their sharpness.

3

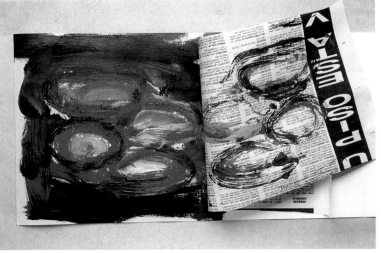

REMEMBER . . .

■ When you correct something by painting over it, make sure that the color you are applying on top has enough covering capacity, and that you match your colors carefully.

■ When you preserve an area on your paper with tape, take into account the quality of the surface so you don't tear it when you peel off the tape.

■ All the techniques demonstrated here require the painter to work with wet paint, so you must know what you are going to do and act quickly.

Water

Due to its changing color and the spontaneity of its movement, water is a subject that poses a real challenge for the painter.

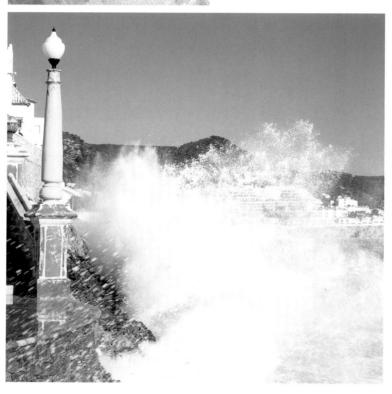

The subject for our exercise is a wave breaking furiously against a seaside promenade.

Two colors are needed to paint this picture: white and cerulean blue, since the whiteness of the spray is the main focus of the image.

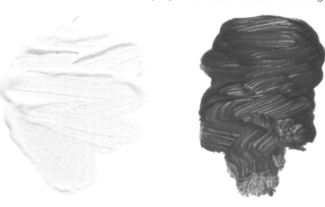

Painting Spray

Water is a substance that constantly changes color according to its background and light; spray and foam, on the other hand, are usually bright white. This explosion of light produced by spray, and the capricious forms made by waves as they crash against the rocks, is technically easy to resolve, although it requires practice with the brush so that the result does not appear too stiff.

1. Because acrylic dries quickly, a quality that allows us to work in stages, we first paint the background and preserve a white space for the spray in the center.

1

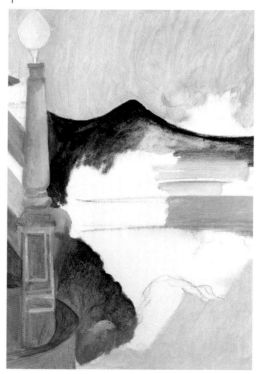

2

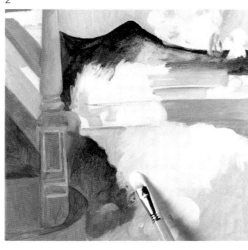

2. White is applied over an already-dry background using the dry brush technique, rubbing the brush softly in circular movements, with very little color on the brush.

3

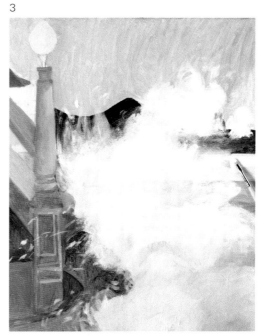

3. Having painted the body of the spray using the dry brush technique, we use a small brush to suggest the edges and the tiny droplets of spray that fall away from the whole.

4

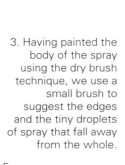

4. After applying the white spray, we notice that the tone of the sky is too pale. We intensify it slightly with a soft blue glaze.

5

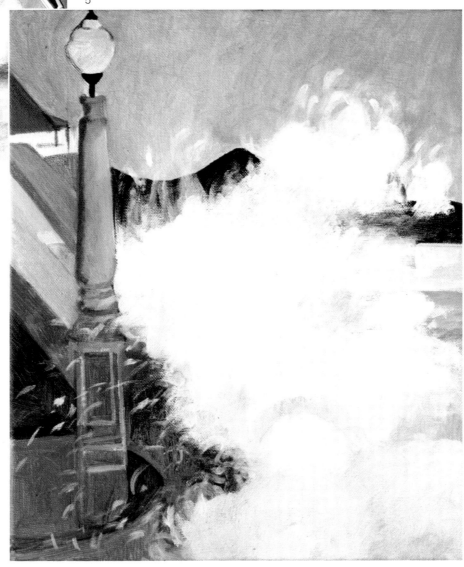

5. In the finished painting we can see how painting in stages has had a positive effect on this subject, since the circular brushwork allows the colors of the background to blush through, preventing the spray from appearing like a flat opaque mass.

REMEMBER . . .

■ More information on the dry brushing technique is found in Tricks of the Trade, pages 52–55.

Skies

A sky can be the sole focus of a painting. Its presence is also an inevitable part of landscapes and seascapes; for this reason, you should learn to paint it with accuracy.

1

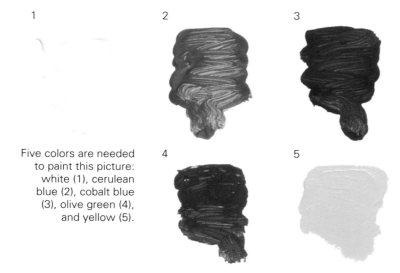

2 3

4 5

Five colors are needed to paint this picture: white (1), cerulean blue (2), cobalt blue (3), olive green (4), and yellow (5).

The subject chosen for this exercise is a beautiful sky filled with clouds whose various shapes and sizes are the true focus of the painting.

Painting the Sky

Just like water, the sky is not always the same color, since it takes on a multitude of hues as the light changes throughout the day. There are also sometimes clouds in the sky whose shapes and colors change continually. For this reason, it is best to sketch their position and the direction of the light when painting from nature because the scene can change from one minute to the next.

When painting masses of clouds, we should suggest their volumes by using their shadows and colors.

1. Having sketched all the outlines in charcoal, we paint a cerulean blue glaze over the entire area of the sky. Brushwork is used to create texture; we avoid a flat stroke.

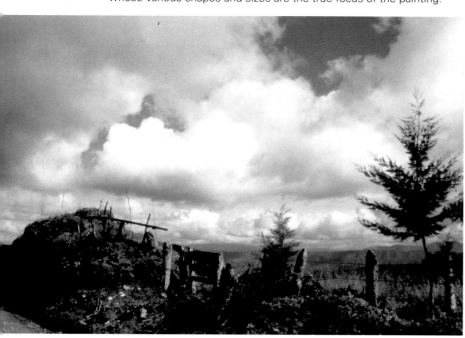

1

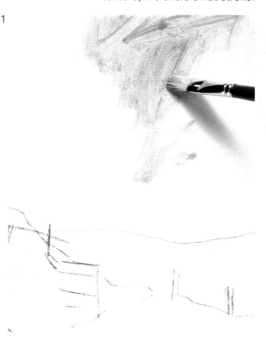

2

3. Once the background is dry, apply a light gray containing cobalt blue and a touch of emerald green. Various tones of this color are used to suggest the shadows of the clouds.

3

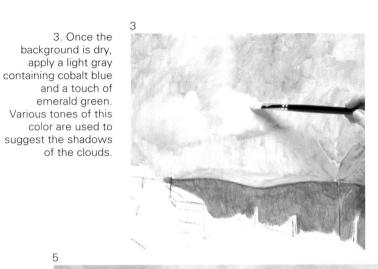

2. Add a touch of olive green to the sky on the left in order to darken the blue slightly and produce a neutral tone. Paint in the land so the white of the canvas won't interfere with your perception of the colors.

4

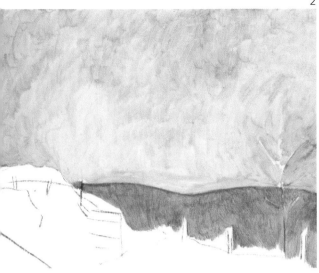

5

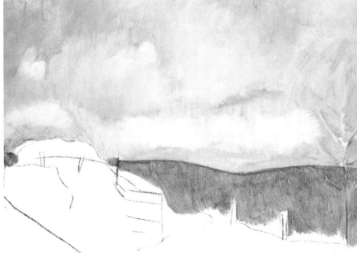

5. The volumes of the clouds are gradually being developed by adding shadows and highlights.

4. Use pure white to paint the highlights, just as before, with subtle circular brushstrokes. Leaving the outlines blurred suggests the characteristic fluffiness of clouds.

6

6. To finish, paint in the land and darken the shadows, especially the part on the left, blending the contours softly and adding touches of green and yellow, barely perceptible but enough to contrast with the cool blue and white areas.

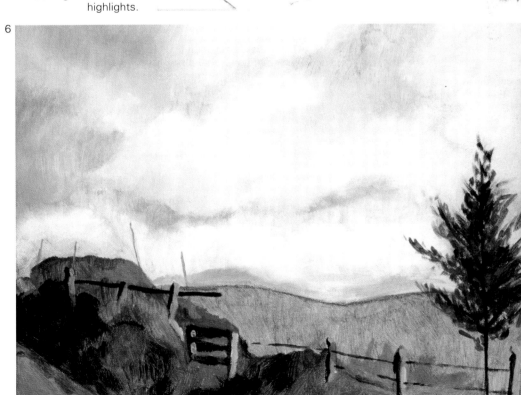

Vegetation

Vegetation is an element that is found in almost all landscapes, city streets, and domestic gardens.

1

2

3

4

5

6

7

Painting Vegetation

When we speak of vegetation, we are basically referring to greenery, although in reality, vegetation can take on a host of different colors and tones, especially in the case of flowers. Also, we are not referring to one specific shade of green, since a field, for instance, may seem to be a homogenous color but, in reality, is made up of many hues.

Seven colors are needed to paint this exercise: white (1), cerulean blue (2), cobalt blue (3), emerald green (4), olive green (5), raw umber (6), and yellow (7).

The subject of this painting, a field containing a tree, will allow us to concentrate on both foliage and grass.

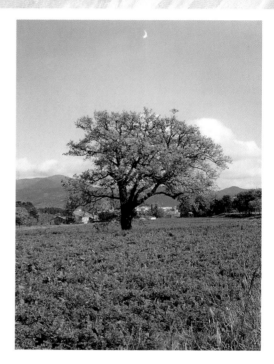

1

1. Begin by painting in the grass with emerald green lightly mixed with olive green and applied with brushstrokes that suggest the texture of the grass.

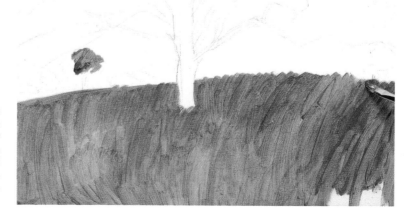

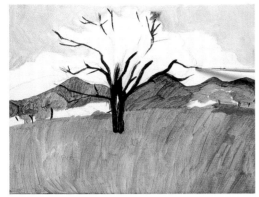

2

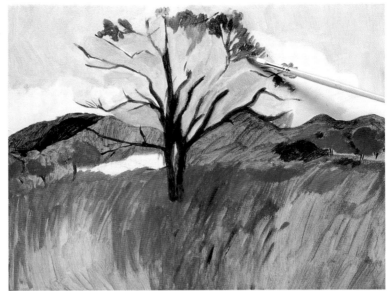

3

2. When the mountains and sky have been painted, fill in the tree trunk and the structure of the branches in raw umber on a dry background.

4

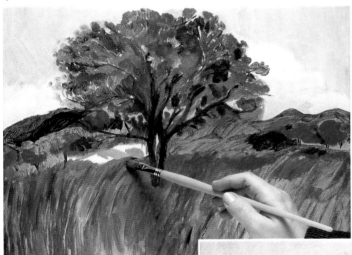

3. Continue working the grass and foliage, using some colors in both areas. This is an excellent opportunity to see the importance of brushwork in a painting; small and short strokes clearly suggest the leaves, while long strokes convey the blades of grass in the field.

4. Once the foliage is complete, return to the field, applying mixes of both greens, yellow, and touches of blue.

5

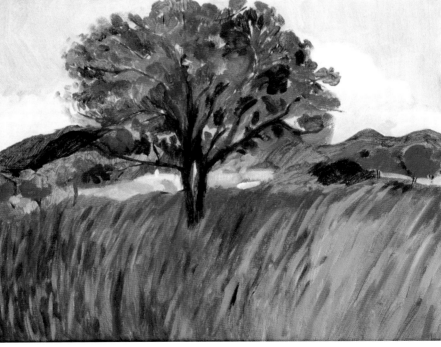

5. In the finished painting we can observe the number of colors that have been produced through mixes and how they were used to create the masses of green foliage and grass.

Flesh Colors

The treatment of the colors and characteristics of human flesh may seem mysterious to the novice painter. Through practice, however, you will discover the right blends to produce skin colors and other characteristics.

Seven colors are required to paint this exercise: white (1), cadmium red (2), yellow ocher (3), burnt sienna (4), raw umber (5), emerald green (6), and yellow (7).

Painting Flesh

Human flesh colors cannot be bought in tubes, since there is no such thing as one flesh color; each individual's skin is made up of many different colors. Light also has an enormous influence on skin color; therefore, the artist has to resort to mixing colors to paint human flesh. Painting the hues of the skin requires a certain amount of knowledge and skill at mixing colors, especially for painting the shadows that produce the sense of volume.

Don't forget that shadows cast by the body on the ground and background are fundamental in giving a human figure its three-dimensionality and weight.

As a subject, we have chosen this model. She is presented from the back in a graceful pose that, without producing striking contrasts, does allow an interesting interplay of light and shadow.

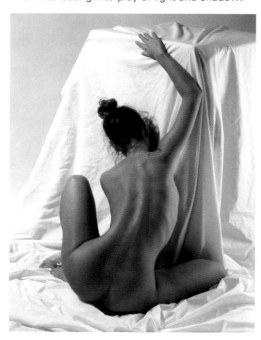

1. Having sketched the general shape of the model in charcoal, brush the lines with a rag to remove excess dust, and paint the first applications of yellow ocher mixed with white.

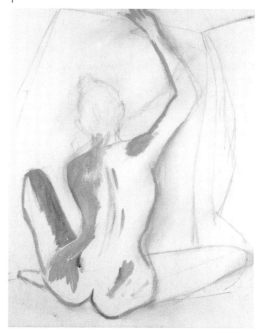

2

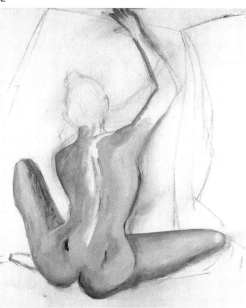

2. Add some red and orange to the first color on the palette to make the new hues that we use to paint some areas of the body. The burnt sienna is applied as a glaze for the shadow of the right leg, and a tinted ocher for the one on the right leg.

3

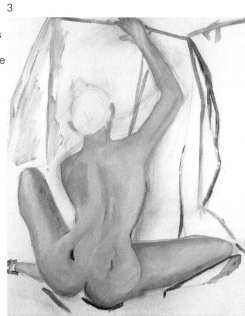

3. At this stage, the palette already contains all the colors necessary to paint this figure. The artist takes advantage of them to create subtle blends over the body and correct tonal values.

4

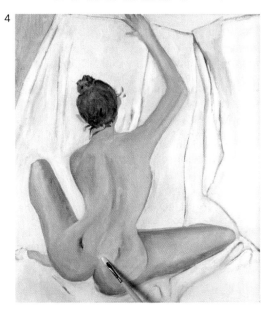

5

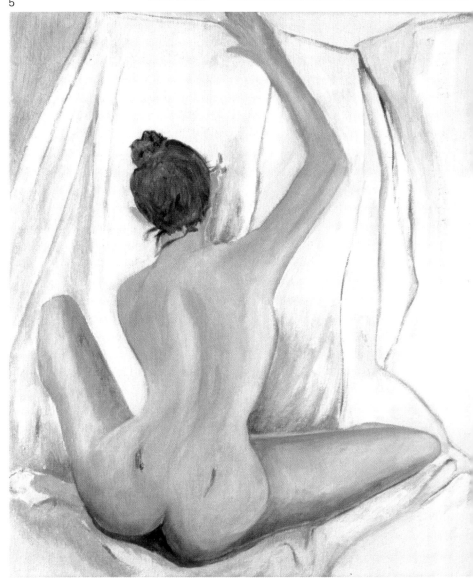

4. Having painted the hair, the figure is almost complete; the only task remaining is to heighten the shadows (the body still appears to float in space) and retouch the highlights. The area is lightened here with a small brush loaded with a mix of orange and white.

5. In this last phase, note how the shadows cast by the figure contribute a sense of depth to the image, pulling it out of the background and situating it firmly on the floor.